DOUBLE ELEPHANT

WALKER EVANS

DOUBLE ELEPHANT / EDITED BY THOMAS ZANDER

DOUBLE ELEPHANT

WALKER EVANS

STEIDL GALERIE THOMAS ZANDER

WALKER EVANS SELECTED PHOTOGRAPHS

The world of the arts owes Walker Evans a special debt. But this specialness cannot be described without first speaking of another debt that is owed Walker Evans, one which is surely not the less pressing for being the regular and ordinary debt that the world of the arts owes to anyone who adds to its store of works of genius. This, Walker Evans has done with the grandest consistency for some four decades – the pictures he has made in the medium of photography are beyond all doubt among the most perfect, the most profoundly significant and moving achievements of visual art in our time. When this has been fully understood, but only then, we can go on to speak of Walker Evans' special service to the world of the arts, which is that in an age whose most authoritative art is characterized by a bold and brilliant subjectivity that seeks eventually to fulfill itself in an entire innocence of external reference, Walker Evans has silently affirmed not only the actual but the ineluctably aesthetic existence of things, of objects. He has required us to recognize that there really are things and persons in the world and that they make an inescapable condition of our lives, whether we like it or not. On the whole, his art puts itself on the side of our liking it, including us to acknowledge the relentless power and mysterious charm of both things, and persons, usually commonplace, mostly sad, often cast off, but permitted by the intermediation of his lens to assert the strangeness and dignity of their perdurable being. The particular and distinguished service to the arts for which Walker Evans is owed a special debt is that in our day of prepotent subjectivity he has retrieved, preserved, and reaffirmed the aesthetic validity of our objective world.

Lionel Trilling
On the occasion of the presentation of an award for distinguished service
to the arts from the National Institute of Arts and Letters, 20 May 1974

WALKER EVANS: SELECTED PHOTOGRAPHS

is a portfolio of fifteen photographs published in a limited edition of seventy-five portfolios, plus fifteen artist's proofs. Lionel Trilling has written an introductory essay about Walker Evans. Each print has been signed and numbered by the artist. All the photographs were printed on Kodak Polycontrast Rapid paper under the supervision of Walker Evans; fourteen by Richard M. A. Benson and John Deeks, and one, *Couple in Car, Ossining, N.Y.* by Lee Friedlander. The prints were mounted on handmade, all-cotton, 300-pound Fabriano Classico paper, debossed by Kathleen Caraccio and Catherine Carine. The text sheets were printed letterpress from Janson types by Howard Gralla and Michael Bixler. The portfolio was manufactured by Brewer-Cantelmo Co., Inc. The project editors were Burton Richard Wolf, Eugene Stuttman, and Lee Friedlander. Design and Typography by Norman Ives.

Edited by Lee Friedlander for The Double Elephant Press Ltd., 205 East 42nd Street, New York, New York, 10017.

1

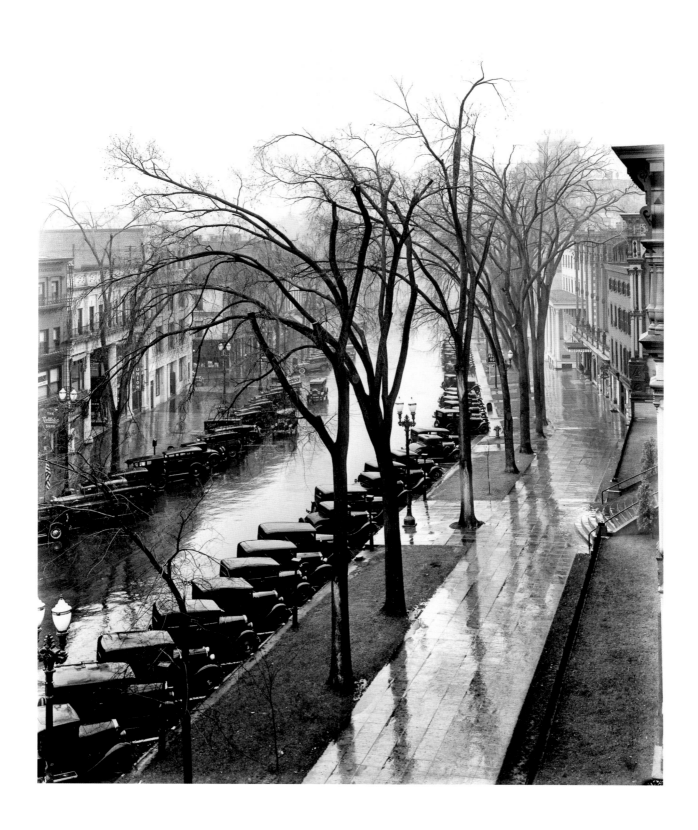

2

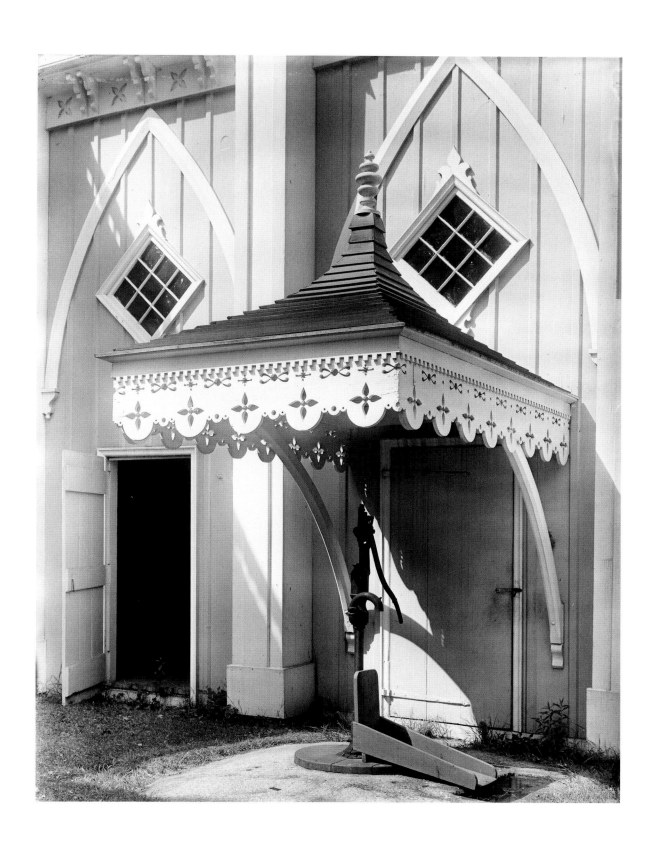

3

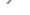
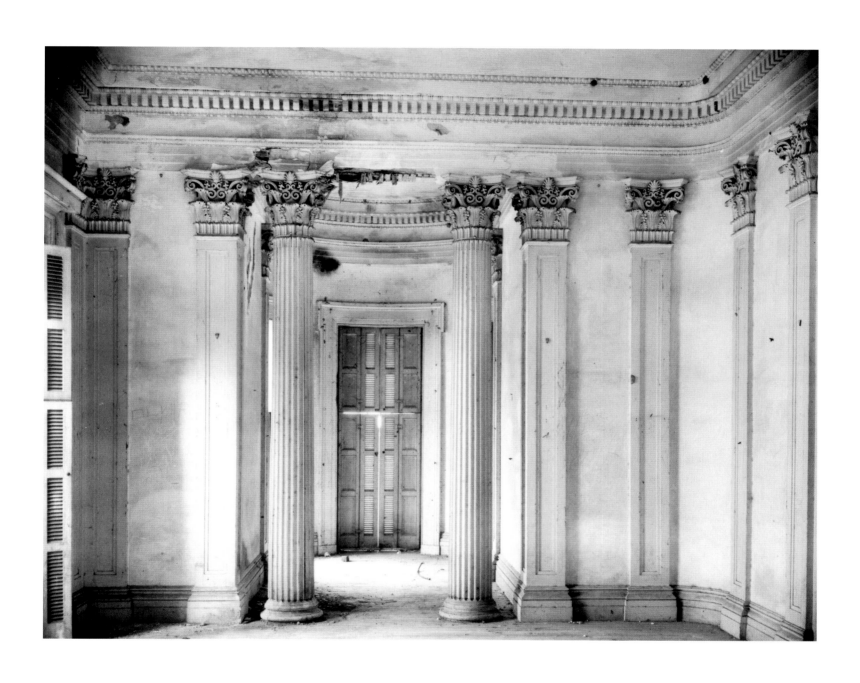

4

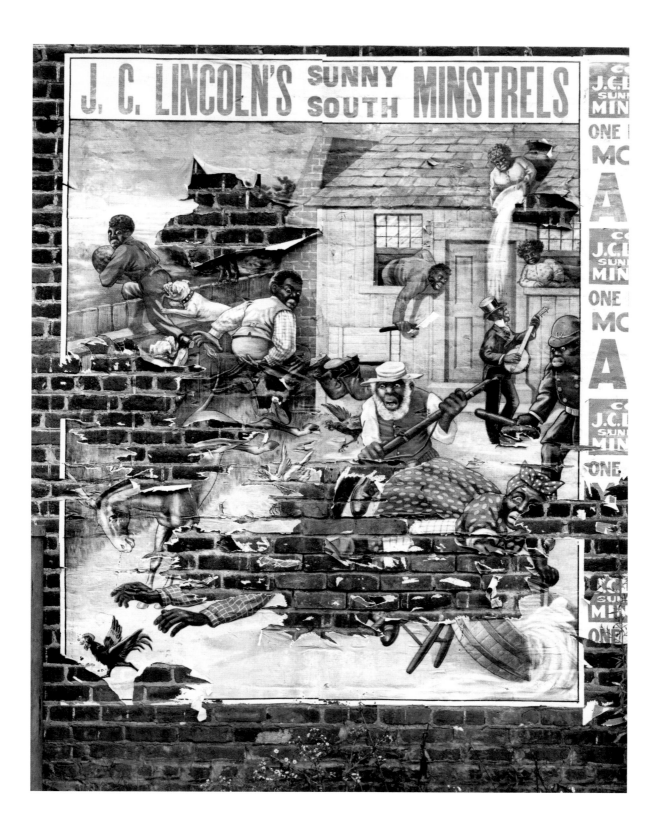

5

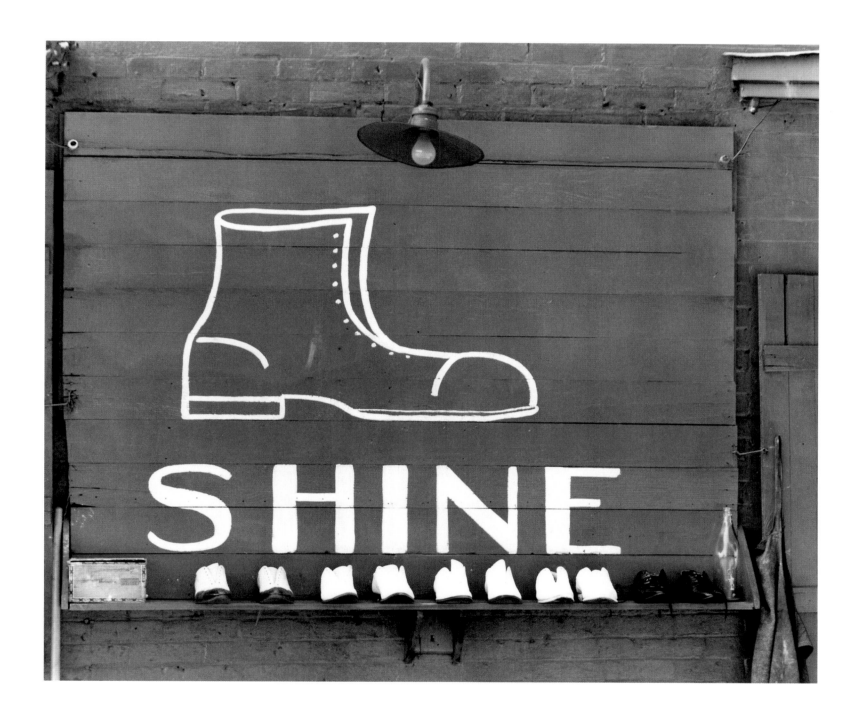

6

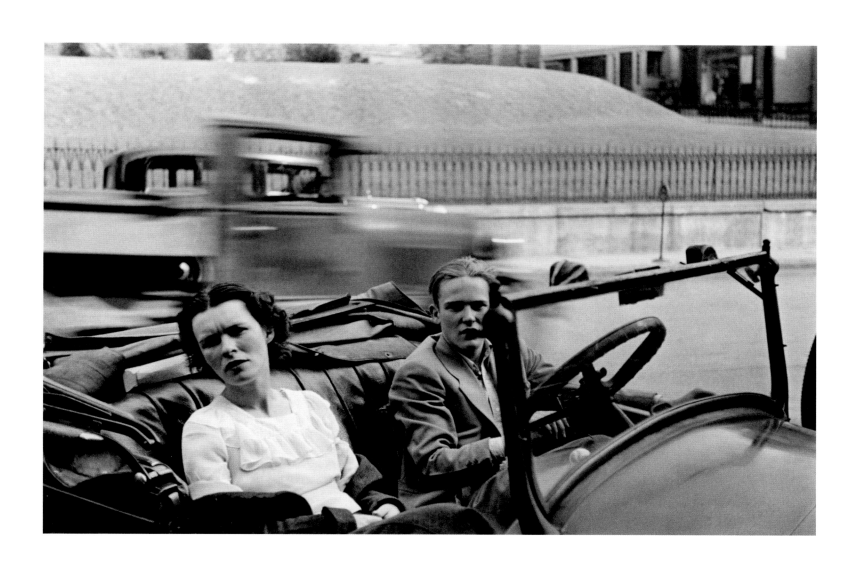

7

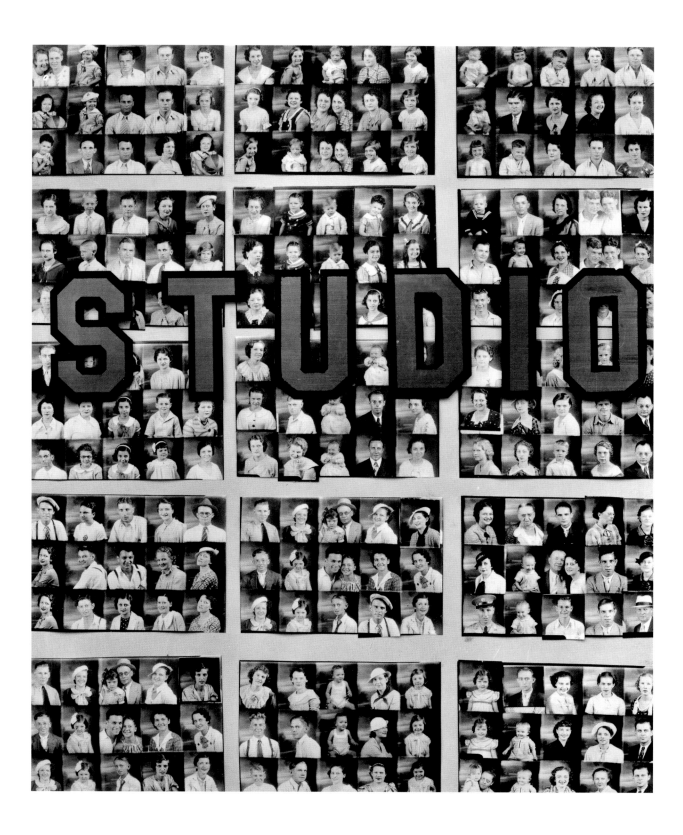

8

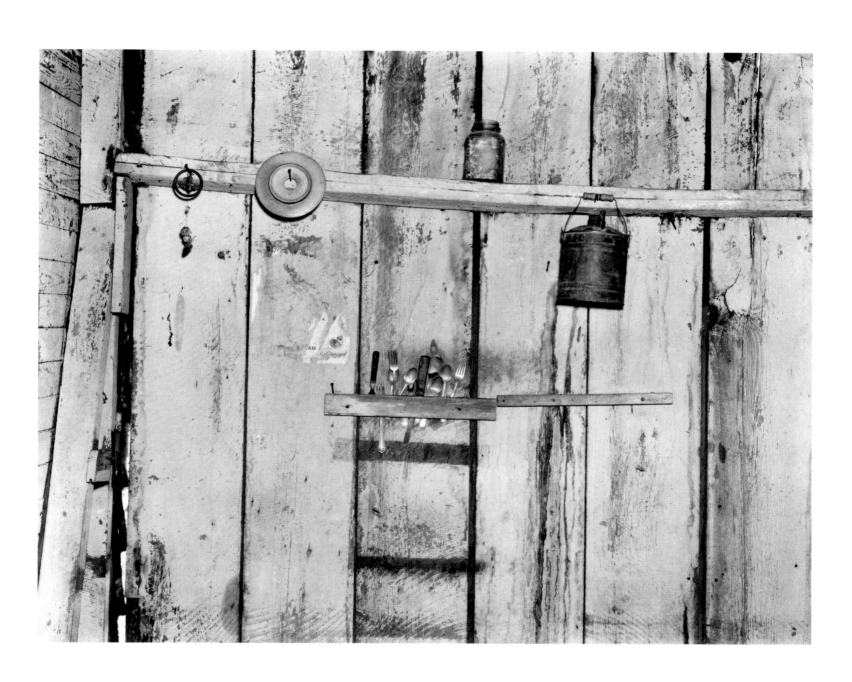

9

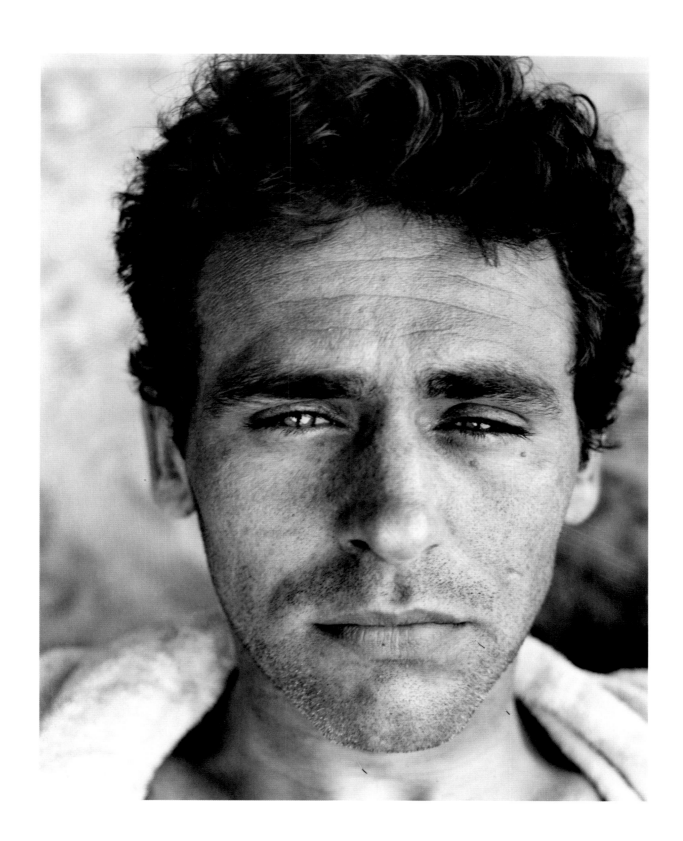

10

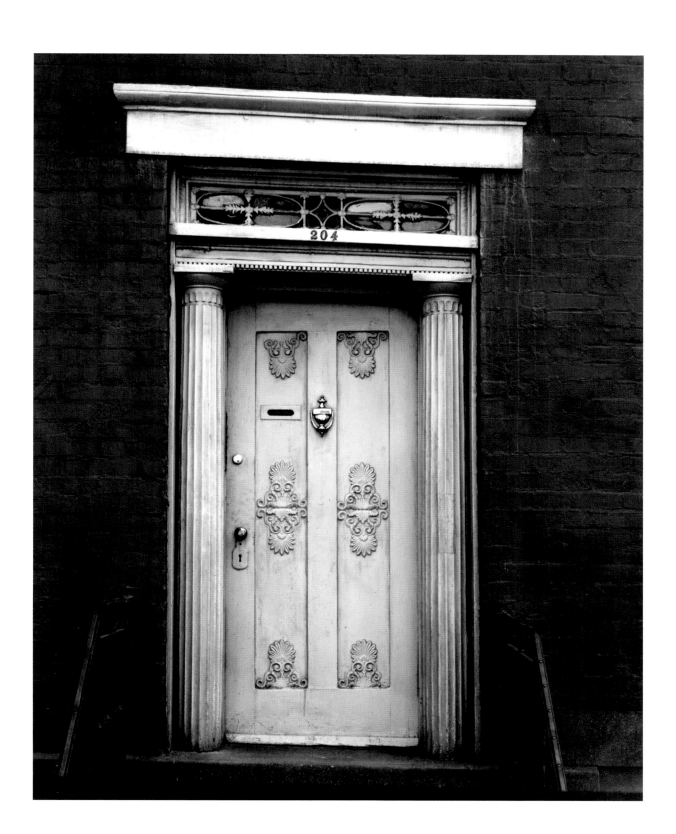

11

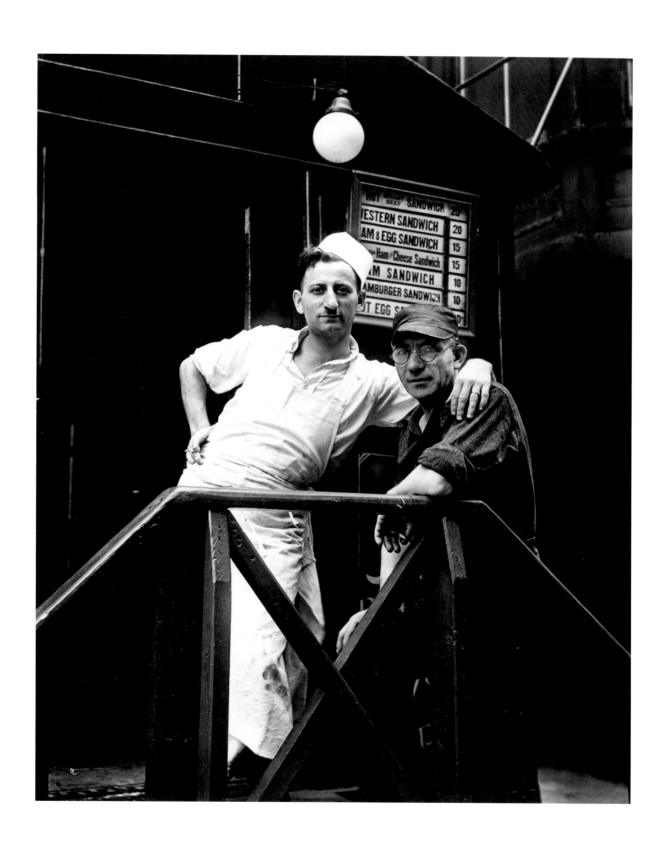

12

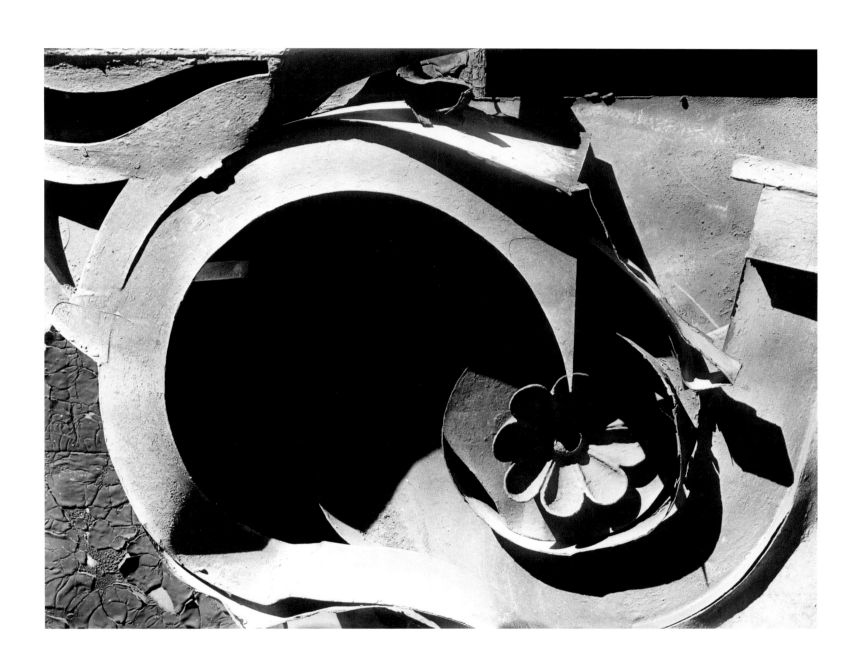

13

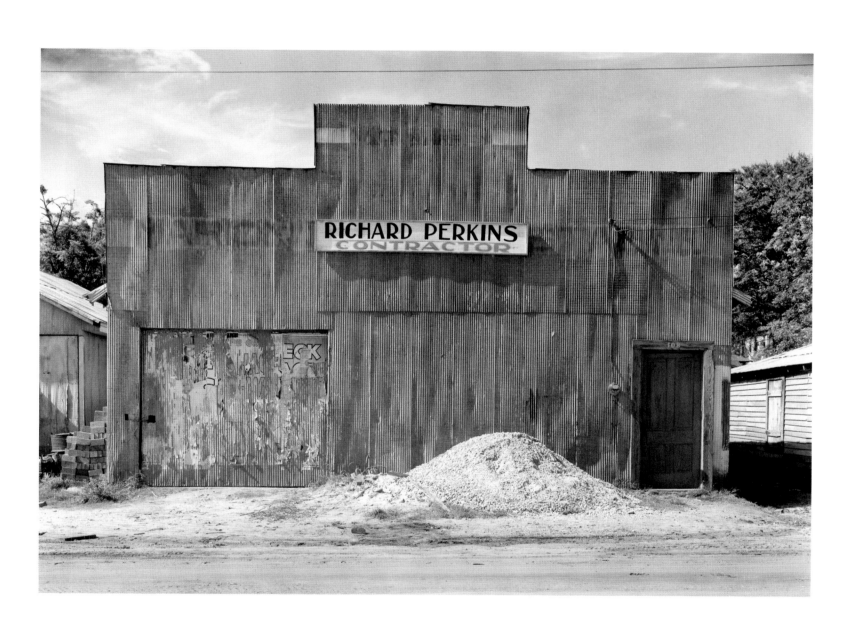

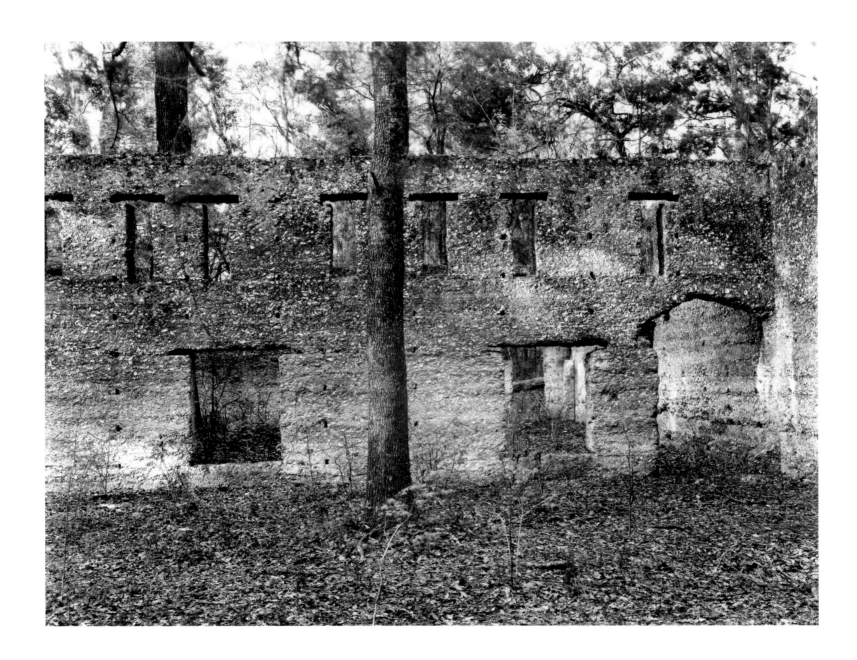

15

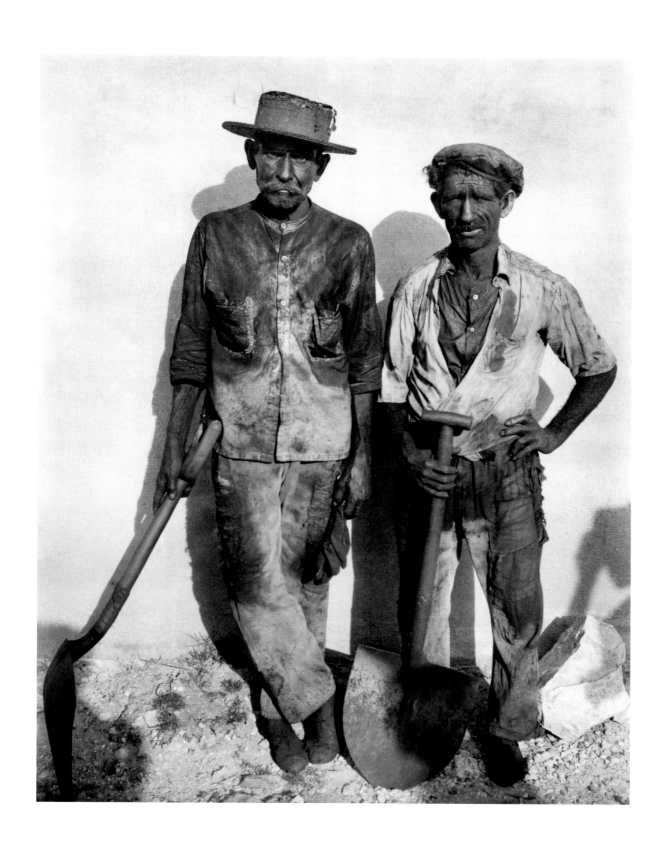

First book edition published in 2015

Image sequence, portfolio description, and introductory
text by Lionel Trilling from the original portfolio.

Editor: Thomas Zander
Project management: Frauke Breede, Anna Höfinghoff
Copyediting: Keonaona Peterson
Book design: Duncan Whyte, Bernard Fischer, Sarah Winter, Gerhard Steidl
Tritone separations by Steidl
Production and printing: Steidl, Göttingen

Steidl
Düstere Str. 4 / 37073 Göttingen, Germany
Phone +49 551 49 60 60 / Fax +49 551 49 60 649
mail@steidl.de
steidl.de

Galerie Thomas Zander
Schönhauser Str. 8 / 50968 Cologne, Germany
Phone +49 221 934 88 56 / Fax +49 221 934 88 58
mail@galeriezander.com
galeriezander.com

ISBN 978-3-86930-743-5
Printed in Germany by Steidl